NORGE

Contemporary Landscapes from the Collection of
Her Majesty Queen Sonja of Norway

March 3 – May 25, 2005

The American-Scandinavian Foundation
Scandinavia House
58 Park Avenue
New York, NY 10016

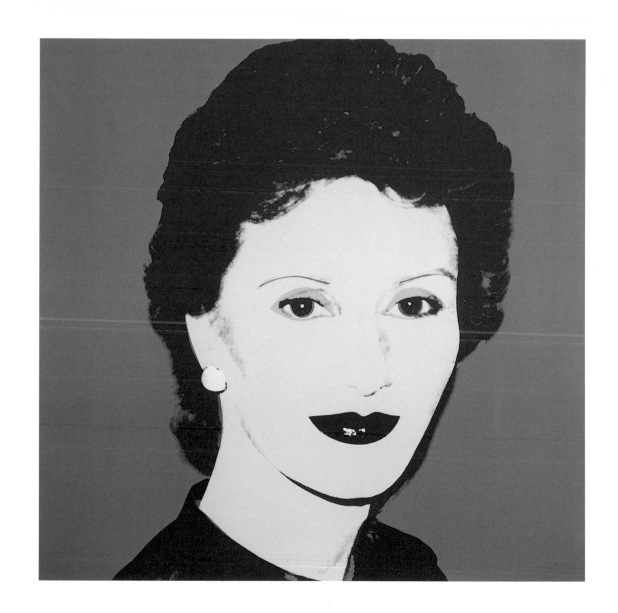

31. Andy Warhol CELEBRITIES: CROWN PRINCESS SONJA, 1982, 102 x 102 cm

PREFACE

The American-Scandinavian Foundation is honored to present *NORGE: Contemporary Landscapes from the Collection of Her Majesty Queen Sonja of Norway.* We are deeply grateful for the participation and cooperation of Her Majesty in the realization of this project, which offers a unique perspective on the visual arts in Norway today. Her Majesty's passion for and extensive knowledge of the visual arts has inspired and educated countless Norwegians for many years. In 1993 to 1995, museumgoers on three continents were introduced to Norwegian art through the exhibition «Winterland,» which Her Majesty oversaw.

NORGE: Contemporary Landscapes from the Collection of Her Majesty Queen Sonja of Norway commences the ASF's yearlong series of programs commemorating the Centennial of Norwegian Independence. One hundred years ago, the union of Norway and Sweden was dissolved. During the past century, Norway has been the focus of an increasingly rich and vibrant visual culture.

For ninety-five years, The American-Scandinavian Foundation has served as the principal ongoing cultural and educational bridge between Norway and the United States. Since its inception, thousands of scholars and artists have been supported by the ASF in the pursuit of their trans-Atlantic studies, and countless Americans have learned about Norwegian life and thought through ASF publications and programs. In recent years, Americans and Norwegians have regularly met in public and private forums at Scandinavia House: The Nordic Center in America, the ASF's New York headquarters.

NORGE: Contemporary Landscapes from the Collection of Her Majesty Queen Sonja of Norway was initiated by the ASF and organized in collaboration with the Royal Court of Norway. Our proposal was warmly received by Her Majesty, even though it requires the long-term loan of some of her most beloved paintings. Throughout planning and organization, Her Majesty has been the guiding spirit of this exhibition, bringing to it an extraordinary enthusiasm, warmth, and keen critical sensibility.

Her Majesty was assisted by Karin Hellandsjø, Consultative Curator, on all aspects of exhibition planning and on the preparation of this catalogue. Ms. Hellandsjø's insights and influence are deeply appreciated. Also appreciated are the efforts expended by the dedicated staff at the Royal Court of Norway and at The American-Scandinavian Foundation.

Edward P. Gallagher
President of The American-Scandinavian Foundation

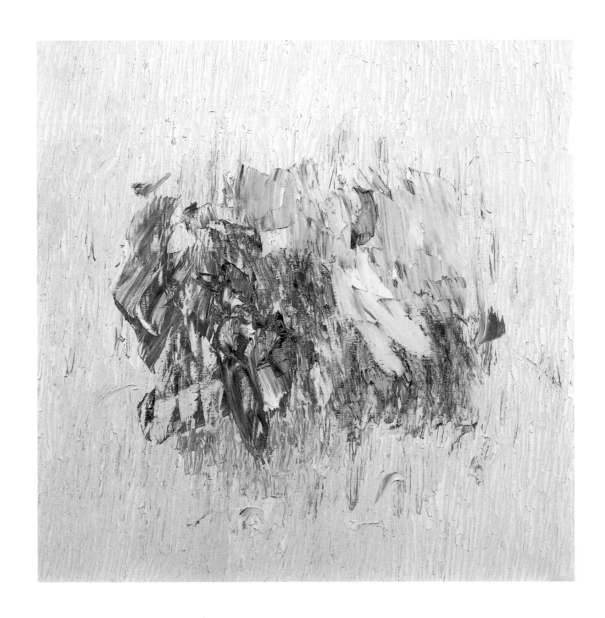

30. Jakob Weidemann SOMMER / SUMMER, 1987, 100 x 100 cm

NORGE
Contemporary Landscapes from
the Collection of Her Majesty Queen Sonja of Norway

It was a beautiful day. We were on a hike in northern Norway. In Leirfjord, a large rectangular steel installation had been placed in the landscape. Everyone thought it was odd.
But I insisted – we should not be discouraged: We should go and have a look!
As we approached, we saw that the seemingly randomly sited construction framed the landscape in an infinite number of perspectives, depending upon where one was standing. The landscape had been there since the dawn of time. Art helps us to realize that.
What more can we ask?

Queen Sonja, in *Impulses,* 2001

Queen Sonja has been interested in, and collected art from an early age. As Crown Princess, and later, as Queen of Norway, most of her time was taken up with public engagements, and art became one of her pleasurable pastimes – a breathing space amongst her extensive public duties. She read art history at university and was an active participant on the Norwegian art and cultural arena, not only its royal patron. She became an active art collector, and consequently, a number of artists became part of her private social circle. There were other artists she enjoyed visiting on her travels across the world, whenever she was able to take time off from her duties. Her meetings with artists such as Robert Rauschenberg, James Rosenquist and Andy Warhol in New York in the 1980's and 1990's, were therefore no chance encounters. One of the things that resulted from these meetings was an unplanned project with Andy Warhol, who made a suite of 6 portraits of her as part of the *Celebrities* series, in 1982.

With the passing of the years, Queen Sonja's art collection grew in size. When she and King Harald moved from their home in Skaugum in Asker, to the Royal Palace in Oslo in 2001, Queen Sonja was persuaded to exhibit her collection. Part of it was also published in book form on this occasion. The decision to share her collection with others in this way was a courageous and daring one. Opening up for public view, it was no longer part of her private sphere alone. There are very few private women collectors in Norway and the Scandinavian countries, and Queen Sonja's decision was greeted with enthusiasm and admiration. The collection is a very personal one, characterized strongly by the collector herself. The relationship between her life experience and

the paintings she has bought is a close one, and the purchase of an artwork is often the result of a spontaneous enthusiasm – an immediate response to the situation. Early on, Queen Sonja decided that she was particularly interested in contemporary art, and that this would constitute the main part of her collection.

I have always found it more stimulating to explore new paintings. It demands a good deal. An image ought to have more to offer than a recognizable motif. It must have a secret. Naturally, I appreciate paintings that are well painted, but if I were to choose, I would almost always prefer the challenge of a new painting. I have never looked to the past in my encounters with art.

Queen Sonja in *Impulses,* 2001

LANDSCAPE

As well as her interest in art and artists, Queen Sonja is well known for her enthusiasm for hiking and skiing trips all over Norway in all seasons. These activities represent another kind of breathing space in her busy working schedule. They are not only an important part of her life – they have made her an expert on the geography and nature of Norway. The Norwegian painter Jakob Weidemann has said that Queen Sonja's paintings are an echo of her life, and it should come as no surprise that the main body of her painting collection consists of landscapes. The pleasure she takes in art, and the pleasure of experiences nature have gone hand in hand throughout her life – viewing some of her paintings often gives her an experience closely akin to experiencing nature first hand. One might say

that Queen Sonja's close contact with nature has coloured her view of art and characterized her choice when acquiring paintings. This is quite natural in a country like Norway where the art of landscape painting is deeply rooted in a romantic tradition, viewing nature as an expression of personal experience.

TRADITION

Johan Christian Dahl (1788-1857) has been called the father of Norwegian painting. It was first and foremost due to his influence that Norwegian painting took shape in the 19th century, and a tradition was established that has characterized much Norwegian art since. Dahl's heroic description of the landscape, observed from a basic, naturalistic position, provided the platform for Norwegian art's close connection with Norwegian nature. Art has of course changed, but the importance of nature has had an impact upon the work of many artists over the years – right up to today.

For many non-Norwegians, Norwegian art was for a long time first and foremost connected with various interpretations of the landscape and with natural phenomena such as the shifting light and dramatic, seasonal changes. This was certainly due to the ideas that took root during the Romantic period with its mystification of the Scandinavian landscape. Countless exhibitions have been produced and publications written on the subject, both nationally and internationally, and exhibition titles such as *Northern Light* and *The Mystic North* have become par for the course. The same holds true for today's art, even though the ways in which artists choose to express themselves change and develop swiftly. And it was the case in the years following

the Second World War, up to the turn of the century; the period that Queen Sonja belongs to, and the period during which most of the paintings in her collection were conceived.

During the 20th century, and especially during the post-war period, artists have been less interested in replicating nature – increasingly, photography overtook that role – but nature has continued to be a source of inspiration. Many post-war artists developed from a cubist starting point, moving gradually towards an area that lay between a perception of reality and abstraction – based upon impressions of nature. These artists moved away from direct allusions to reality - the motifs they worked with were movement, forces and structures in nature, rather than a specific pictorial description of a landscape alone. Even though these were abstract impressions, there was no hiding the fact that particular experiences of nature often provided the basis for the work, and this was often apparent in the titles. One of the most renowned, Norwegian, post-war artists working in this way was Jakob Weidemann. His artistic production came to influence the Norwegian art world for decades, and he played an important role as Queen Sonja's friend and advisor. His work forms a major part of her collection.

Jakob Weidemann, more than any other artist, renewed the art of Norwegian landscape painting after the Second World War. He gave it a new *look,* more in line with contemporary international visual language. Jean Bazaine, the French painter, believed it was important that these post-war artists found a way back to nature, rediscovering what he called the structural unity between human beings and their surroundings. Cultivating the emotional and expressive qualities of colour, shape, line and materials was the way forward, according to Bazaine. Jakob Weidemann put it like this:

I want to make an abstraction of the Norwegian forest floor.
The colour of the anthills on a dark, rainy day, the mysticism hidden in the shadows of the spruces and the smile of a pale birch trunk. I want to discover the character of every single thing – silvery white branches with rusty leaves, grey stones and branches of spruce against the black earth. We have wood nymphs and tarns, pixies and paganism, superstition and all kinds of devilment that we must never lose sight of. They belong to us. To paint like a Hungarian Frenchman is madness. Think of our streams in the spring – there's nothing like them in the whole world. Think of the Coltsfoot that pokes up its smiling head from the rotting earth, or the light on the virgin green of the new leaves in the harsh, Nordic sunshine. And what of the autumn, as it disappears into winter in a spectacular sea of flames – an unparalleled feat of strength. Our light is not soft – as it is over the poppy fields in France. It is hard and clean and nowhere in the world has such clear cut contours as in Norway.

For Weidemann's generation, and those who followed, it was no longer important to hold on to the illusion of the painting as a random section of reality. On the contrary, these artists wanted to emphasise other aspects of their art – such as the brushstrokes, shapes, colour and structure.

11

Nevertheless, many of them were closely related to a romantic landscape tradition and to the idea of landscape as imbued with a metaphysical dimension - a symbol for human feelings. This is something that interests Queen Sonja too. On her many hiking trips in the Norwegian countryside she has always enjoyed the company of others – people with whom she can share the immediate pleasures, experiences and feelings that occur on such trips. She has often chosen artists to accompany her, because of their ability to introduce her to new, undiscovered aspects of the landscape, thus amplifying the experience of nature at first hand. It is also the artists who through their work brings Queen Sonja back into contact with nature.

NATURE'S LIGHT

The 13 Norwegian artists who are represented in this exhibition with one work or more, span 50 years of Norwegian art. The way in which they work is diverse – ranging from the expressive and lyrically abstract, to the almost figurative; from small, delicate watercolours, to monumental, allegorical landscapes and video-based visions of nature. If one is searching for a common denominator, it must be LIGHT. Light is particularly relevant to the changing seasons in Norway, and this is something that certainly captures Queen Sonja's interest. She describes it evocatively thus:

When you go skiing in the spring, surrounded by
whiteness, you can hear the sound of gurgling
underneath the snow.
Then the water appears along with the sounds it makes.
Then the snow disappears and the green arrives.
Then the birds come back, the flowers, the smells…
This is all so fantastic.

Jakob Weidemann, Knut Rumohr, Kåre Tveter and Anna-Eva Bergman all belong to a generation born before 1945, but they were all most active during the post-war period. They developed a lyrical-abstract visual language with many variations, based upon impressions of nature. From the forest floor, **Jakob Weidemann** turned his attention to wild meadow flowers, to the wonder of the spring, when nature is reborn after its winter hibernation. He wanted to portray the way in which flowers sought the light, and his light-filled painterly transformations of experiences from nature sought to portray this beauty. He regarded meadows of flowers, as well as each tiny spring flower as a cosmic resurrection, portraying them as a confession to life itself.

Knut Rumohr came from western Norway, from Sognefjorden – a landscape that he continued to paint all his life. The steep mountainsides, the fiord with its slopes of naked rock, interrupted by shaggy pinewoods became his main source of inspiration, and in his hunt for the light and the changing colours of the seasons, he was influenced by the palette of colours used in traditional Norwegian Folk Art. There is a recognizable seasonal theme to **Kåre Tveter's** poetic visions of landscape too. His delicate watercolours

and canvases capture the play of light at all times of day and night, the year round. He has painted the light in the forests, plains, marshes and lakes of his native eastern Norway, as well as the magnificent landscapes of Svalbard (Spitzbergen) with their dramatic, constantly shifting light conditions.

Anna-Eva Bergman left Norway to live in France in the early 1950's, but it was nevertheless Norwegian nature and the memories of it that inspired her art. In a way, all Bergmann's work from 1952 to 1987 were reflections upon her homeland, but not in an illustrative manner, or as mirror images, replicating concrete motifs. Her work is a search for the essence of her country's landscape. In order to capture the characteristic light of northern Norway, which interested her in particular, she used gold, bronze and silver leaf in her work. By doing so, she translated memories from and about this light and landscape into a universal language, transforming them into visionary landscape paintings interpreted in contemporary, abstract terms.

The younger painters whose work is represented in Queen Sonja's collection, represent more or less a generation of artists who began their careers in the 1970's, apart from the youngest, Thomas Pihl. To a greater degree than before, these artists belong to the international art scene – they travel extensively and participate in exhibitions all over the world. Two of them also live and work abroad; Olav Christopher Jenssen in Berlin and Thomas Pihl in New York. Nevertheless, the Norwegian landscape as a source of inspiration is the common denominator. The sensuality and intensity of the light is a central element in their work.

This is particularly apparent in the work of **Thomas Pihl** and **Bjørn Sigurd Tufta,** who both work with a layer-upon-layer technique in which the process becomes an integral part of the work. They construct inner landscapes from paint – one working with rough, sculptural strokes, the other with thin, transparent washes. The traces left by these processes often give the work a dream-like, veiled quality, in which the light seems to vibrate underneath and behind the surface. Pihl and Tufta – like more than half of the artists represented in the exhibition – come from the west of Norway. They have roots in the same landscape that Queen Sonja has practically made her own. **Marianne Heske** comes from this area too, and few have managed to promote their childhood homeland through their art as she has. She participated in the Youth Biennale in Paris in 1980. On this occasion she actually moved an entire traditional wooden building from Tafjord to the Centre Pompidou. More recently she has used advanced video techniques to introduce us to the kind of light we are not familiar with, throwing the landscape formations into concentrated relief.

Another artist who has roots in the west of Norway, although eastern Norway, and other, more mystical landscapes have had more importance for his artistic career, is **Alf Ertsland**. The lonely tree, the low horizon and the quivering light – the motifs of the painting in the exhibition – are typical of his work. On the other hand, **Ørnulf Opdahl** is a painter who has never let go of the landscape that continues to inspire him – the mountains, sea, sky and light of the country around Ålesund. In mid-life, he chose to move back there, to the island of Godøy. Since then he has developed

a painterly language in which pure impressions of the landscape are cultivated and simplified, becoming non-figurative. The starting point is often a fiord panorama, with steep mountainsides, an angry sea or small details which he often treats with under-painted layers of colour wash, so the light appears to emanate from inside the painting. Just like a true romantic, Opdahl is concerned with mediating the forces of nature and nature itself as an expression of personal experience. Dream and reality are melted into one.

Norway is a long country with an extensive coastline and dramatic landscapes of fiords and mountains, but it is also a country with mountain plains and deep forests, with trolls and sprites. Queen Sonja is also familiar with and fascinated by this kind of landscape. The artist couple, **Hanne Borchgrevink** and **Tore Hansen** have chosen to make their home in this kind of area in eastern Norway. They work in different ways, but are both interested in the relationship and interplay between humans and nature. Tore Hansen is particularly fascinated by the forest, by fairytales and myths. His paintings of humans and animals in landscapes are often executed in a consciously naïve manner, almost like the primitive rock engravings of ancient times. Hanne Borchgrevink has made the simplified house form her «signature»; houses in landscapes. The buildings are a play of colour and shape. They fill the picture plane in a pattern that is often abstract, but the way in which we associate the shape of a house to the idea of a place to live, gives another dimension – they become living organisms. Whilst Hanne Borchgrevink's images are characterized by peacefulness and harmony, other more worrying, surrealistic

elements are present in **Leonard Rickhard's** work. His landscapes may seem to be quite concrete, filled with houses and other objects, but as he himself says, he does not paint landscapes, but models of landscapes. The contrast between technological elements and military huts and buildings on the one hand, and birch woods and cosy houses on the other, creates a kind of anxiety. The light in these paintings is another disquieting factor. By acquiring these paintings, Queen Sonja has taken a step away from her direct contact with nature, allowing herself to be fascinated by this constructed, ambivalent landscape. Perhaps it is exactly this kind of exciting and challenging interplay, as well as the cunning use of light that attracted her to Rickhard's work. Light is an important factor in **Olav Christopher Jenssen's** work too. The light and intense play of colour in the painting chosen for the exhibition lead one's thoughts back to nature and the experiences it offers. Jenssen himself left the landscape of his childhood in order to live outside Norway, yet he too talks about his connection with its landscape and the sense of belonging to it.

Thomas Pihl is one of the youngest artists represented in Queen Sonja's Collection. His subtle, monochrome painting has been selected for the exhibition, showing the range of works in the collection, and the Queen's curiosity and interest in the most recent contemporary art and her ability to see new things. For the Queen, Thomas Pihl's painting also embodies the essence of a direct experience with nature.

Art as abstraction, as nature itself, and art that shows the

outer parameters of nature are all brought together in the work of these artists in different ways, dependent upon their own particular style. The range of work made available by the Queen shows a breadth of expression that springs from the landscapes of the entire country, from Finnmark in the north, via the west of Norway, to the deep eastern forests.

In a special section of the exhibition, a choice of work from the book *Resonances* is shown. This is a book of Queen Sonja's own photographs and writing, which gives an insight into her own experience of the landscapes of western Norway, illustrated with watercolours by Ørnulf Opdahl.

Queen Sonja's involvement with Norwegian art and culture has a long history. Throughout the years she has not only opened and visited numerous exhibitions and given lectures. She has also worked actively as a curator in various connections. Her contribution has elicited much respect.
The painter Jakob Weidemann made the following statement in a speech held in 2001:

Queen Sonja bears within her the strange little word «culture». Without her we would be a poorer nation. If our politicians possessed just a bit of her will, enthusiasm and insight, we would have made far more progress in this country. The Queen seeks, and finds answers in unspoken words and in the poetry of paintings – the most silent language of all.

Perhaps one of the most important contributions the Queen has made, is to use her position to promote and draw attention to Norwegian contemporary art. This exhibition with selected work from her own Collection is the best example of this achievement.

Karin Hellandsjø
Director, Henie-Onstad Artcenter

Accompaning the illustrated works on pages 16 to 71 are statements by the artists followed by statements of Queen Sonja, rendered in italics.

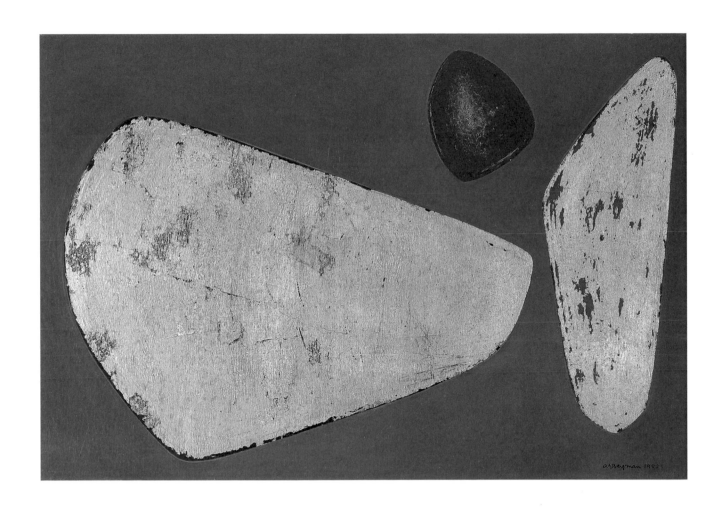

1. Anna-Eva Bergman VINGESKYGGE / SHADOW OF A WING, 1955, 46 x 72 cm

I dream about Finnmark and northern Norway. The light there makes me ecstatic. It lies in layers, giving the impression of different spaces that are simultaneously close and far away. There seems to be a layer of air between the rays of light and these air layers create their own perspective. It's mystical.

ANNA-EVA BERGMAN

———————————

The way in which Bergmann manages to give the
impression of a mighty mountain in such small
format is impressive. She also manages to
use silver and gold leaf in a non-decorative manner,
which is quite a balancing act for an artist.
Her paintings with a blue horizon give me the same
kind of feeling of infinity that I experience
when I'm skiing across the mountain plains
in a landscape of white snow with a strip of blue
sky. The landscape is in continual motion
and as a participant, fantastic experiences occur
second for second. That furthest away point,
right on the edge of our field of vision –
will we ever get there?

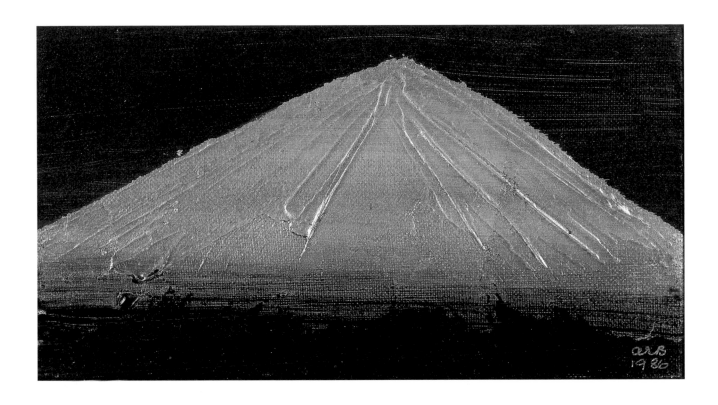

2. Anna-Eva Bergman SØLVFJELL / SILVER MOUNTAIN, 1986, *12 x 21,5 cm*

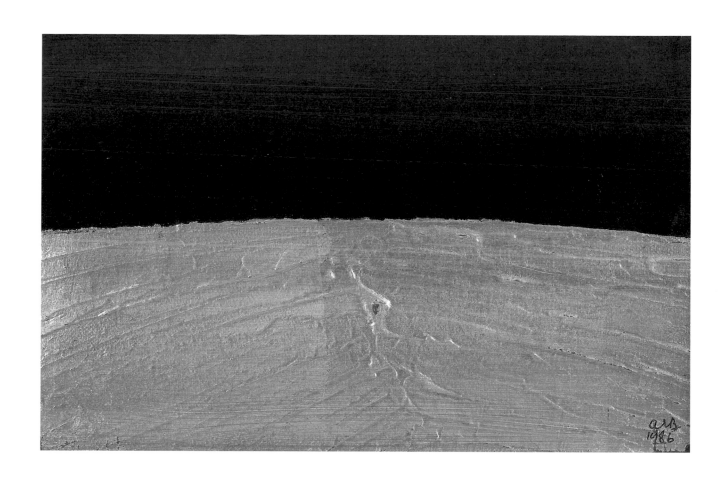

3. Anna-Eva Bergman SØLVHAV / SILVER SEA, 1986, 14,5 x 22 cm

A successful naïvist manages to include the essential: To fill the picture plane with a very personal image which is painted with a strong, visual energy. Exaggeration is an important agent. I think and consider things too much whilst I work to be called a naïve painter, but the naïvist and myself are probably seeking the same kinds of qualities in our work.

Shape is the aid that facilitates and brings together the content matter. My interest in working with flat surfaces and colour were the things that drew me to working with the house form. I also happen to like houses, especially the sight of a single house, viewed from the outside. I'm also drawn to the contrast between a peaceful exterior and the multitude of activities that take place inside houses.[1]

The flat surfaces are folded out, creating an unreal feeling, but there is life within the house, because there are three peep-holes. There is a cold feeling to the white side, there is warmth in the grey, the black is threatening, whilst the yellow light promises everything that is good. The house is lopsided, crooked and fragile. The little red line is the only thing holding the house up.

HANNE BORCHGREVINK

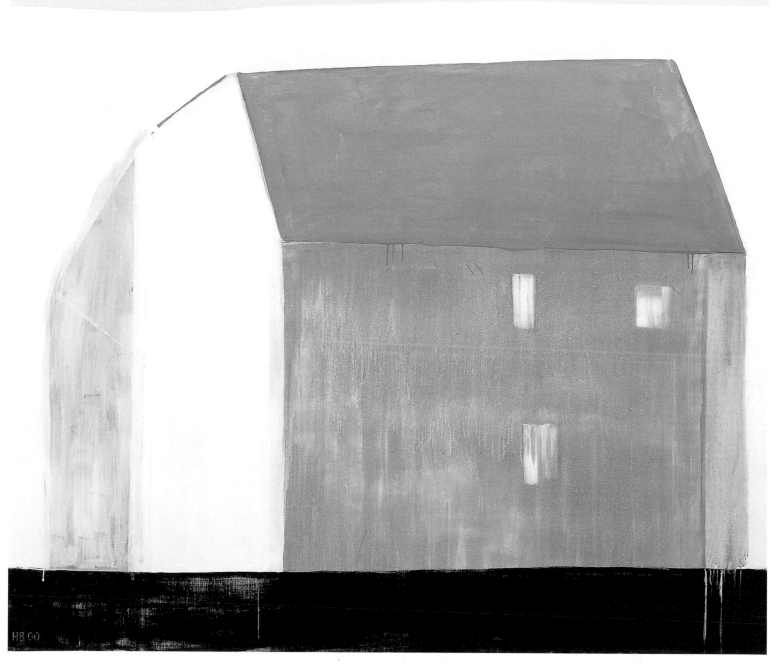

4. Hanne Borchgrevink SOLSKINN / SUNSHINE, 2000, 160 x 180 cm

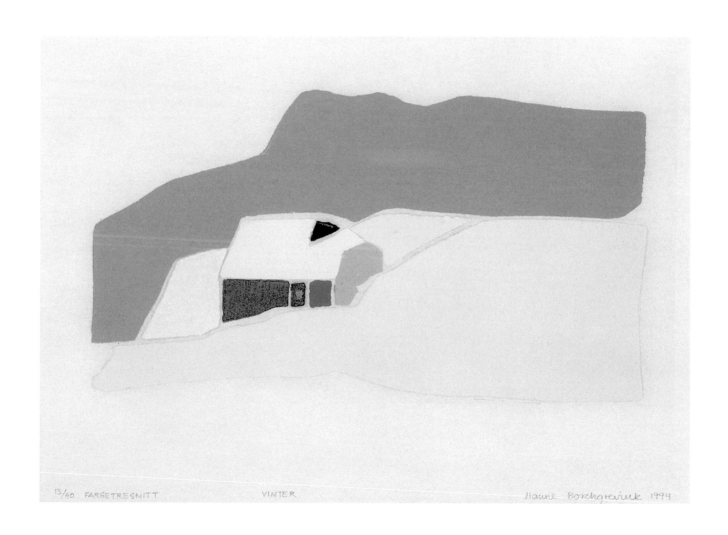

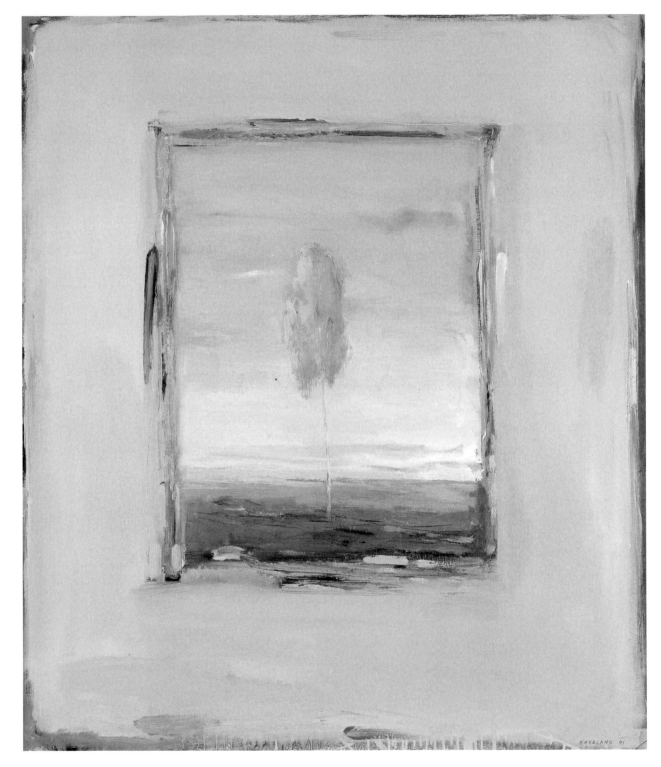

6. Alf Ertsland LANDSKAP MED TRE / LANDSCAPE WITH TREE, 1987, 100 x 85 cm

ALF ERTSLAND

An exhibition I had in 1987 was characterized by the fact that I had visited a number of stave churches and folk museums in Norway, and had become really interested in traditional Norwegian painting techniques and was fascinated by the simple landscapes as they were painted as décor on old furniture etc. I began to make simple, ornamental things.

Colour and nuances are important – they create the character of a painting. If the images are very expressive, I become uneasy. I am more at home with images that communicate in a meditative, quiet way. Sometimes my paintings have a melancholy air about them.[2]

———————————

The lightness and texture of this painting appeals to me. There is a carefulness and sensitivity in the brushstrokes – something dream-like and undefined. The colours are cheerful, but there is a melancholy aspect to it, due to the tree, which stands alone. In works like this, the artist has obviously been influenced by the folk art traditions of Norway, and the sensitive, painterly rendition strikes a chord with me.

T|he things I paint need to be recognizable, otherwise the motif loses something important. However, painting an elk in a naturalistic way is boring, and far too normal. I can't capture the soul of the elk, or its elegant character. It wouldn't be art. Art is exactly the opposite – it means diving deeply inside yourself, reacting to the motif you are working with, and making it your own.[3]

———————————

Tore Hansen is masterly in his interpretations of the
deep Norwegian forests with all their mysticism,
wild animals and the exciting things that happen there.
He is also a great humorist and there is a certain degree
of naivety in the way he works. Just look at the way
in which he portrays a tree – the way in which he
simplifies things. And look at the elk –
just like Giacometti, he elongates the figure.
Sometimes he only describes a detail,
yet creates a unity.

TORE HANSEN

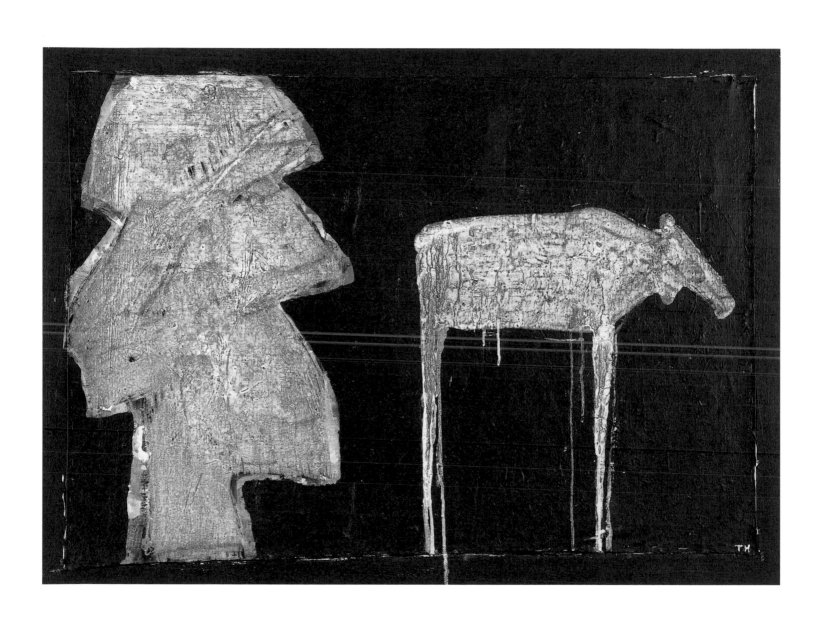

7. Tore Hansen SOVENDE ELG / SLEEPING MOOSE, 2003, 72 x 98 cm

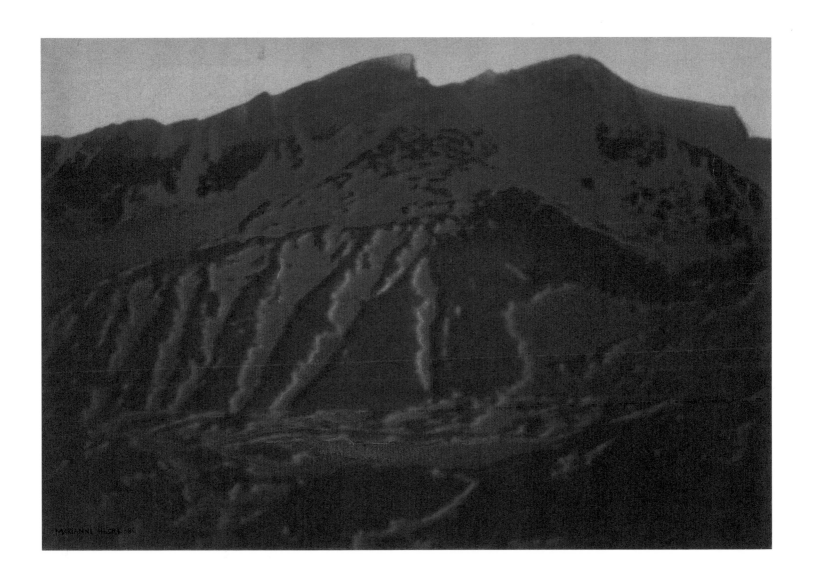

8. Marianne Heske UTEN TITTEL / WITHOUT TITLE, 1986, 66 x 94 cm

MARIANNE HESKE

I am fascinated by the infinity, the clarity and the severity of the Norwegian mountains. Human beings need to experience continuity, connections and dimensions in life. In short, Rome has St. Peters – Norway has its mountains.

A philosopher once said «the purely aesthetic should have a connection with an existential dimension». This is what I work with.[4]

She portrays the landscape that I appreciate perhaps most in the entire country – the landscapes of western Norway. She is a fascinating artist – her versatility and the way she experiments with techniques as well as content matter is always exciting. With nature as a starting point, she constantly seeks new ways to work, as in video-based works such as this. She is influenced by the landscape she comes from, but by using unorthodox ways of working she has forged her own path, a path that is exciting to follow.

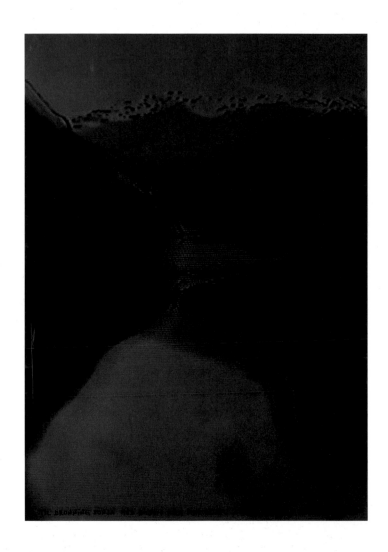

10. Marianne Heske TAFJORD, 2001, 65,5 x 47 cm

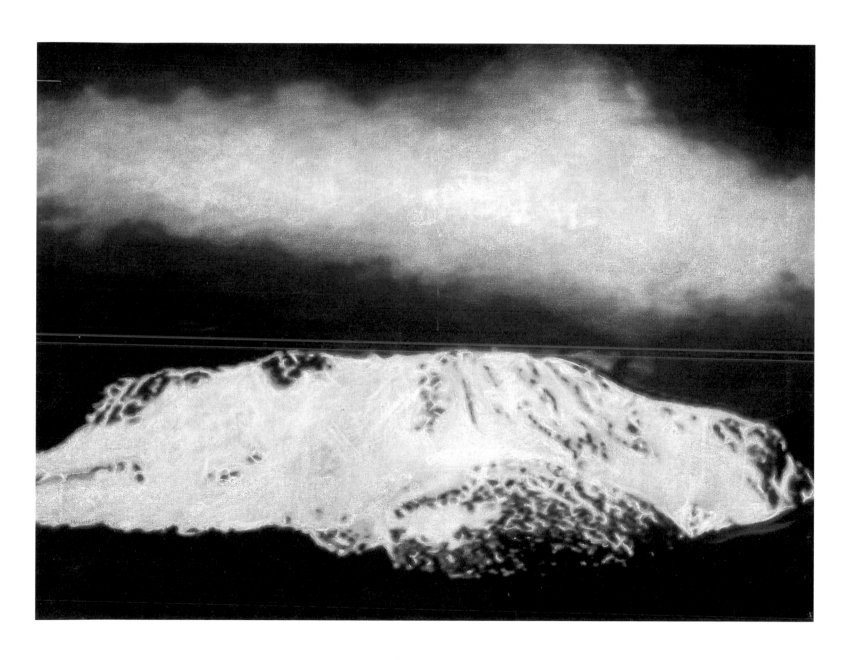

9. Marianne Heske NATT VED FANARÅKEN / NIGHT BY FANARAAKEN, 1987, 96 x 129 cm

began working figuratively in 1985, and feel that I have a definition of landscape that is not linked to any particular place geographically, but is something I feel I have inside me – a kind of landscape of belonging that I relate to.

I work with a limited choice of colours, and I always tell myself: the next colour is the most important. The colours are activated by one another, they don't stand alone.[5]

This painting is like a tapestry that the painter has woven with the thread of life. This is spring and summer – the power of nature interpreted with intense colours. Nevertheless, there is a cooler side to it, and the viewer is shut out by the grid structure. The painting has a strong presence and one takes great pleasure in the dynamic play of colour.

OLAV CHRISTOPHER JENSSEN

11. Olav Christopher Jenssen INSULAN, 1997, 220 x 200 cm

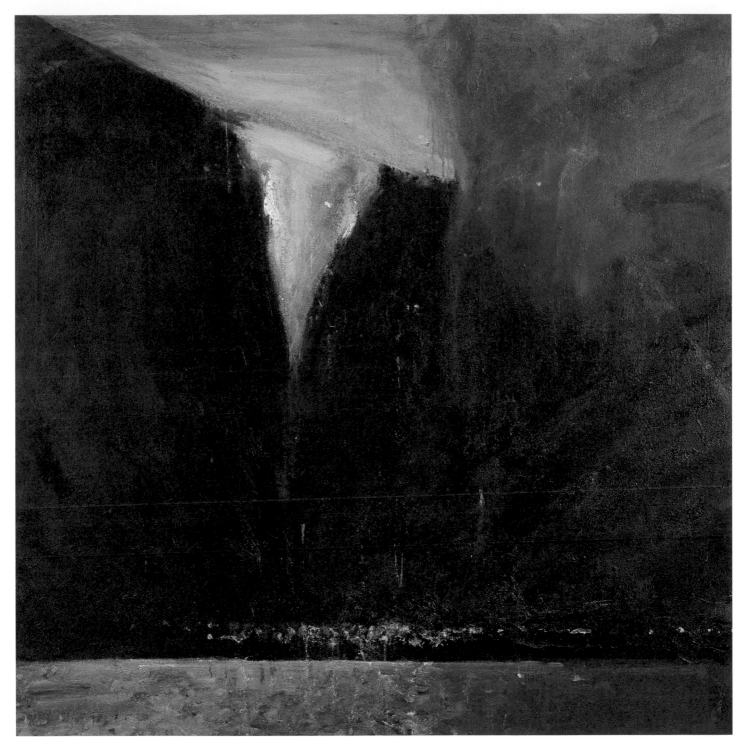

12. Ørnulf Opdahl FJORDBYGD / VILLAGE BY THE FJORD, 1991, 145 x 145 cm

ØRNULF OPDAHL

It's hellish to stand outside and paint with the light changing constantly. There are a million details, and then you have to start the work of simplifying… I have never mastered this kind of dialogue with nature. I base my paintings on memories, on experiences that have sunk in. I have to build upon the harshness of the impressions I have and let them ripen inside me.[6]

Ørnulf Opdahl is our greatest mediator of the landscapes of western Norway. When one enjoys walking in this particular environment, it's fantastic to admire his painterly ability to capture the light with physical brushstrokes. He manages to portray the saturated atmosphere one finds in the wet elements of nature by playing with the contrast between black and white. He's a real old salt, and it's when he's out on the fiord that he sees the mountains the way we do in his paintings. That's his own characteristic perspective.

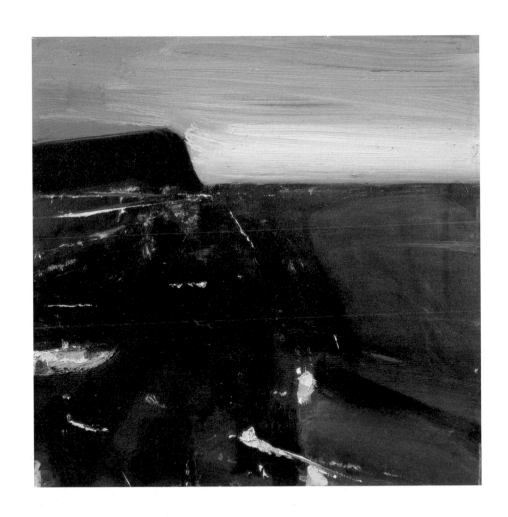

13. Ørnulf Opdahl KVELD – ÅLESUND / EVENING – ÅLESUND, 1997, 50 x 50 cm

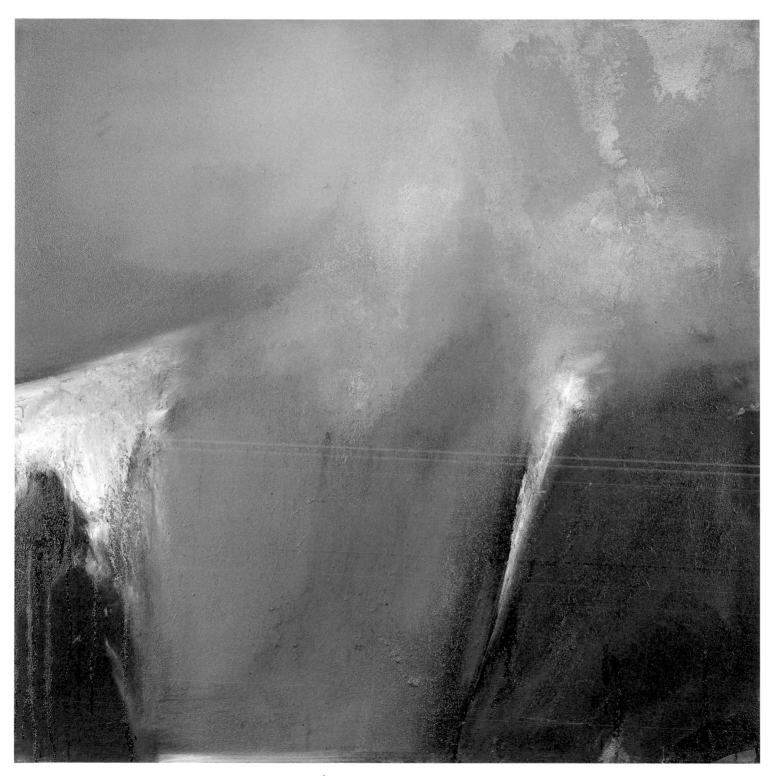

14. Ørnulf Opdahl GRÅVÆR / OVERCAST WEATHER, 1998, 121,5 x 121,5 cm

want to create calm paintings in a world in which the senses are constantly under assault.

I hope to stimulate the eye to produce an active and connected way of seeing; a way of seeing which ranges from perceiving the obvious to that which is extremely subtle and barely visible. It is a rational as well as an intuitive and subjective process. It is a seeing which captures «reality» and records and discerns information, but also mirrors other senses: seeing as feeling, seeing as listening, seeing as sensation.[7]

THOMAS PIHL

To me, this is also nature - like ice under the snow.
The incredible transparent, beautiful aqua-aqua colour
that occurs when the sun shines, lighting up the ice.
The play of colour in nature surprises me anew each time
I see it. It's incredible to experience how different
and many-hued a mountainside can be when the sun
moves over the edge in the morning; turning
the water aqua-blue, as in Pihl's painting.
We can follow the way in which the mountainside is
illuminated, lighting up the landscape little by
little, until we too are in the sun.
This is a fantastic experience.

15. Thomas Pihl PREARTICULATION NO. 12, 2004, 123 x 152,5 cm

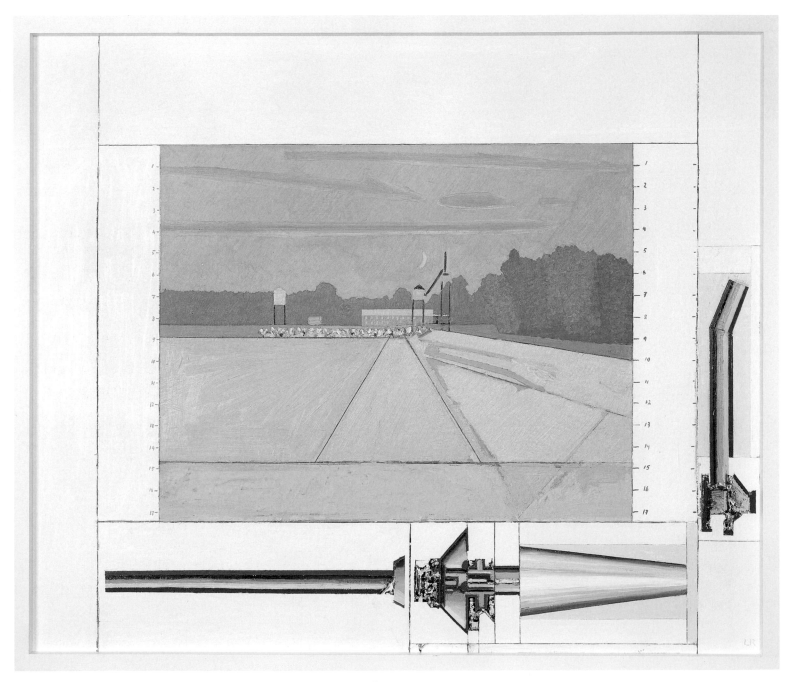

16. Leonard Rickhard I DIALOG MED STILLHETEN – NYMÅNE / IN DIALOGUE WITH SILENCE – NEW MOON, 2001, 152 x 178 cm

LEONARD RICKHARD

I do not paint landscapes, but I paint models of it, which introduces a surrealistic element.

I use sunlight - morning sun or evening sun – as a stationary, ambient element. The sun shines on the buildings, the birch or pinewoods. There is perhaps something that needs to be explained away in all this. Simultaneously, I try to establish a dialogue between a kind of idyll on the one hand and a dramatic scenario on the other.[8]

Harmony and contrast are both present in Leonard Rickhard's paintings – in his choice of colour as well as motif. The softness of the colours introduces an almost romantic element that contrasts with the concrete, structural, machine-like elements.
This is really quite a romantic painting – it has an evening ambience about it, with the yellow moon and the warm light spilling from the illuminated windows. The beautiful pale yellow and green-grey tones of the landscape create a feeling of both calm and uneasiness.
It is night, but the light seems to be daylight.
At the same time, the gaze is drawn to the machine-like elements at the bottom of the painting, which seem to be underground.
I don't find the answers, but I never get tired of asking the questions.

I have never liked naturalism in art. It is neither necessary nor possible to copy nature. Nature is perfect just as it is. My paintings are personal experiences. Nature is always my source of inspiration – the landscapes of western Norway in particular. It's something I have in my body. I am particularly fascinated by the seasons. Each season has its own colours, its own painterly points. The high mountains are the most beautiful – they are so perfect, so untouched and timeless. It's like walking in infinity itself.[9]

KNUT RUMOHR

He doesn't paint the landscape in concrete terms, but rather the extraordinary forces of nature in the landscapes of western Norway. This is something that has always fascinated me. There is an in-built power in his paintings – especially in the way he paints and uses colour – that one instinctively feels the dramatic force of the landscape. The four paintings in the exhibition are interpretations of the four seasons. In «Spring Thaw» one is aware of the final battle between winter and spring with its melting snow. The seasons progress in «Glowing Landscape of Summer» and «Arm of the Fiord», in which the water wedges itself into a particularly harsh-looking mountain landscape on an autumn day. In «Detail of Snow and Ice», we meet the winter, yet feel the closeness of the spring thaw in the snow that compacts before it breaks up and the spring melt takes over. Those poor lumps of snow and ice – they are probably quite aware of the fact that they are shortly to be transformed into water. Drama and excitement are certainly present here.

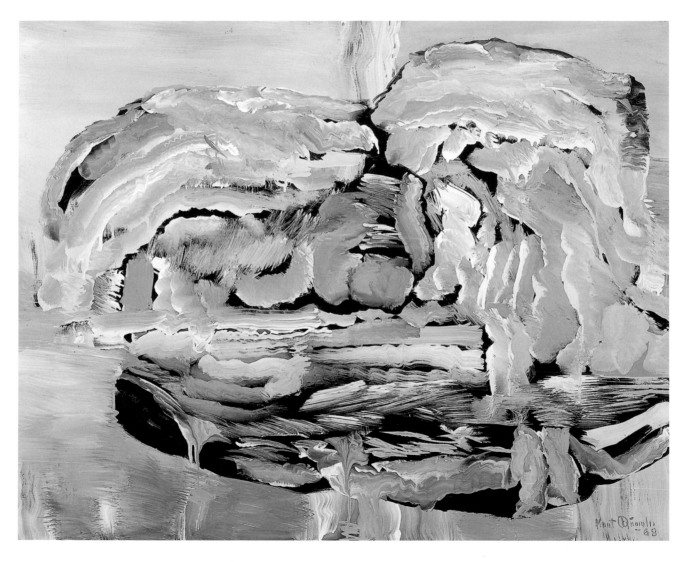

17. Knut Rumohr DETALJ I SNE OG IS / DETAIL IN SNOW AND ICE, 1968, 80 x 100 cm

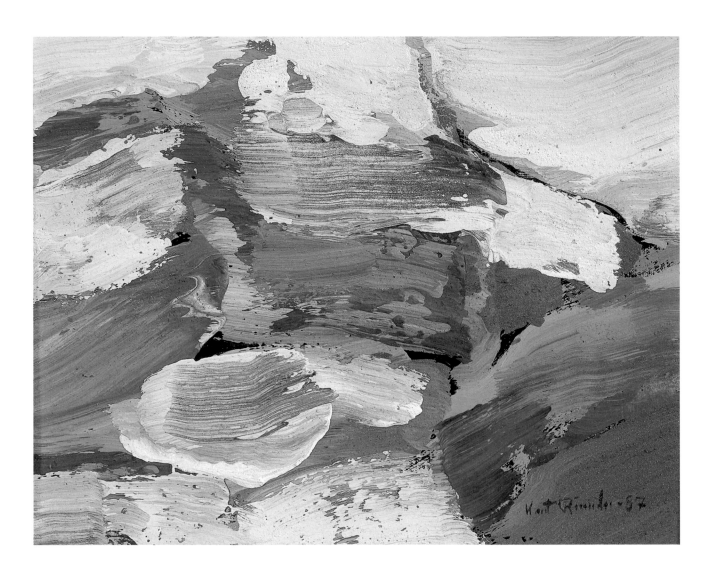

19. Knut Rumohr VÅRLØSNING / SPRING THAW, 1987, 22 x 28 cm

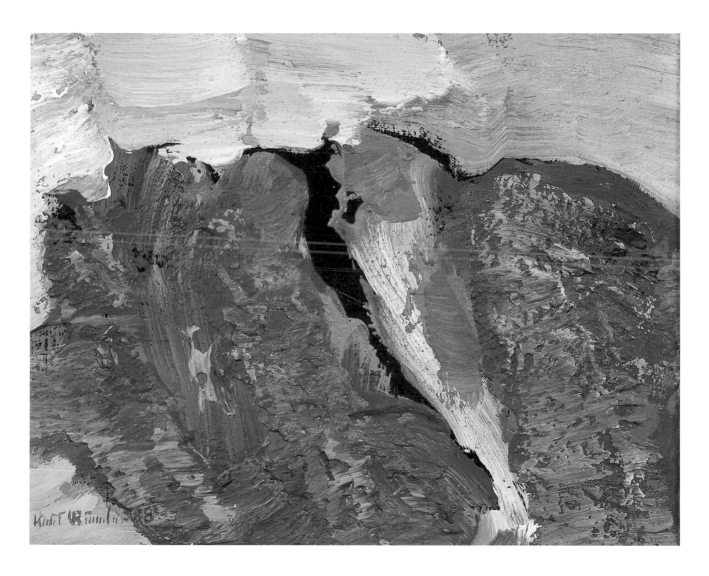

20. Knut Rumohr FJORDARM / ARM OF THE FJORD, 1988, 22 x 28 cm

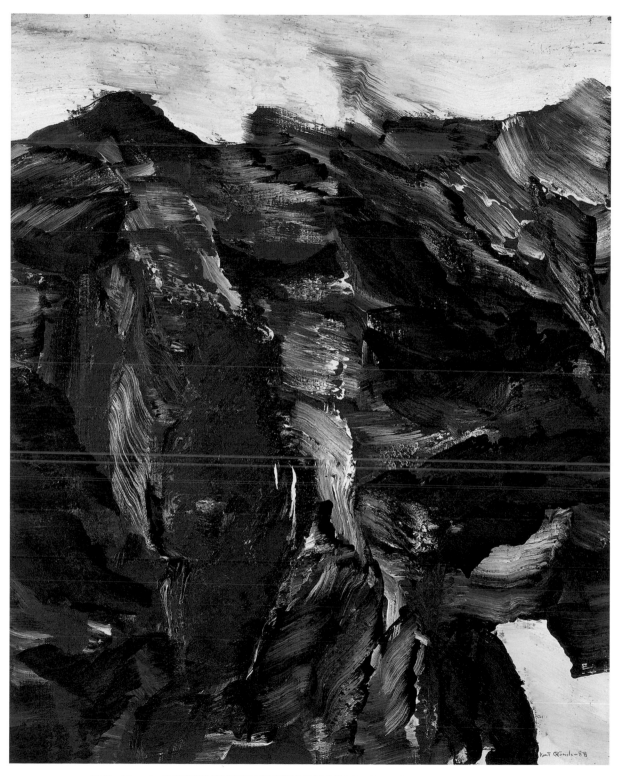

18. Knut Rumohr GLØDENDE SOMMERLANDSKAP / GLOWING LANDSCAPE OF SUMMER, 1988, 100 x 80 cm

21. Bjørn Sigurd Tufta JANUA COELI IV, 1993–1998, 60 x 120 cm

BJØRN SIGURD TUFTA

My landscapes lie within the paintings. They are meditative landscapes.

One might say that I cultivate the art of classical painting. I work with planes and space. I like the ambiguity I can create by hiding something behind many layers, where it lies smouldering. Some things do not offer themselves up directly, but I don't make up stories, and have no wish to press my private thoughts upon the viewer. Nevertheless, I invest a part of myself in every picture I paint.[10]

Bjørn Sigurd Tufta is a gentle and a technically excellent painter. The process necessary to achieve the kinds of nuances we find in the paintings is extraordinary. The surface treatment is masterly. Tufta is able to paint the viewer into a contemplative frame of mind. When I stand before these paintings, I am immediately calm and at peace. It's a good feeling.

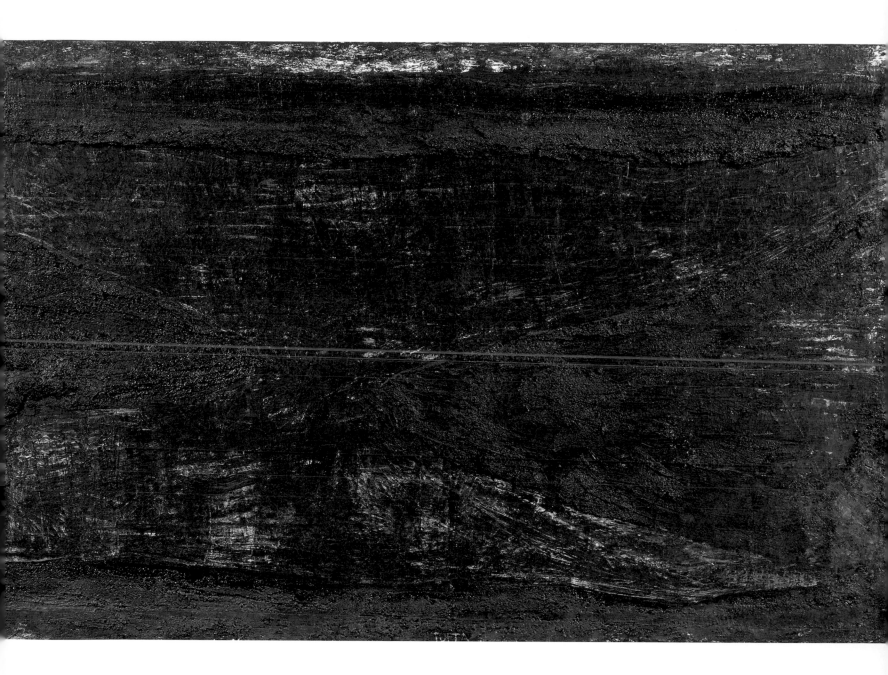

22. Bjørn Sigurd Tufta EKKO – KYST / ECHO – COAST, 1985, 120 x 185 cm

am always searching for light and space. I quite often use black to intensify the light. Light portrays an existence we can only imagine, because it has no material substance and because it cannot be felt in concrete terms. Nevertheless, it is visible.

I experience the light in the winter forests and the winter light itself as visible music. To me, there is a rhythm to the play of the trees against one another – their trunks and branches. Year after year I return here, to these feelings of harmony, of rhythm – to the protection, the safety and the restfulness of the winter forest.[11]

KÅRE TVETER

To me, Kåre Tveter is a master of light. His paintings
have a dream-like, almost ethereal quality, and
one is struck by the sensitivity and carefulness of his
technique – the way the brush barely touches the canvas,
yet manages to bring out an atmosphere, a landscape
that makes a deep impression.
I am very familiar with these motifs; the winter
atmosphere at Skaugum and Svalbard and the lonely
house in the morning light.

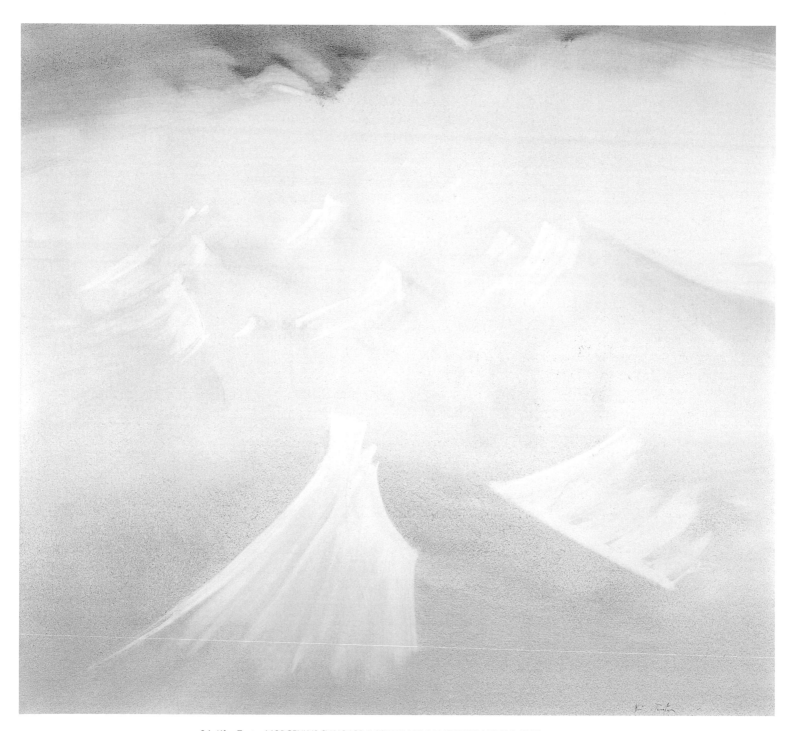

24. Kåre Tveter MORGENLYS SVALBARD II / SVALBARD IN MORNING LIGHT II, 1987, 99 x 110 cm

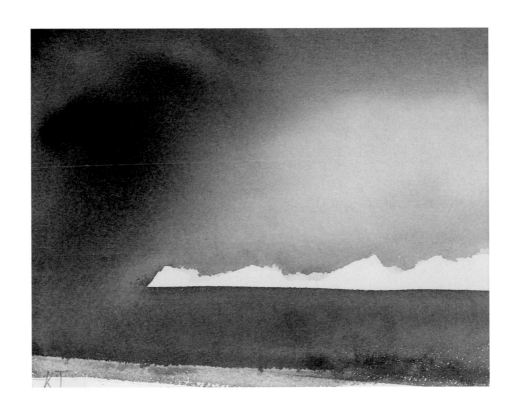

26. Kåre Tveter ISFJORDEN / THE ICE FJORD, 1984, 13 x 17 cm

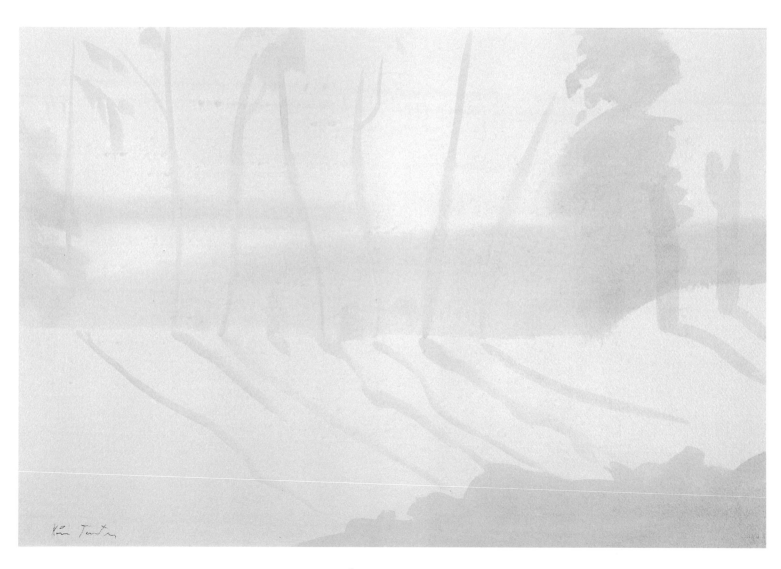

23. Kåre Tveter VINTERSTEMNING PÅ SKAUGUM / WINTER AT SKAUGUM, 1984, 36 x 53 cm

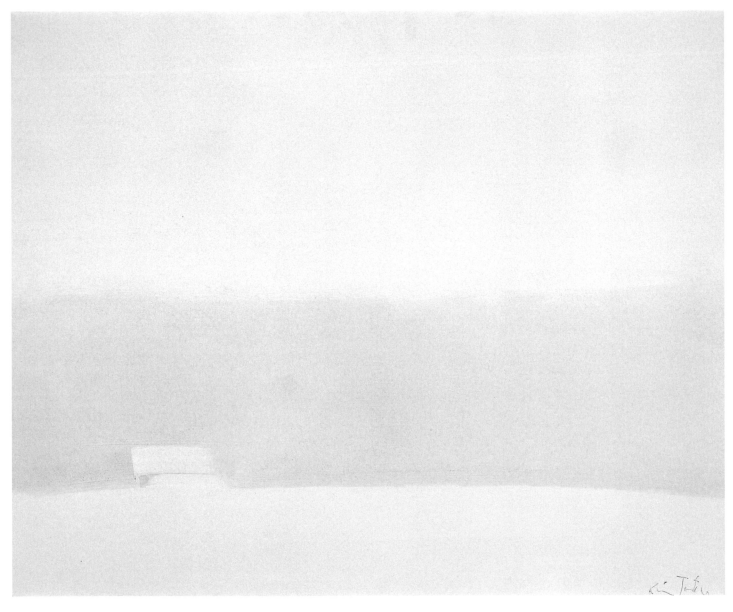

25. Kåre Tveter MORGEN / MORNING, 1988–89, 65 x 80 cm

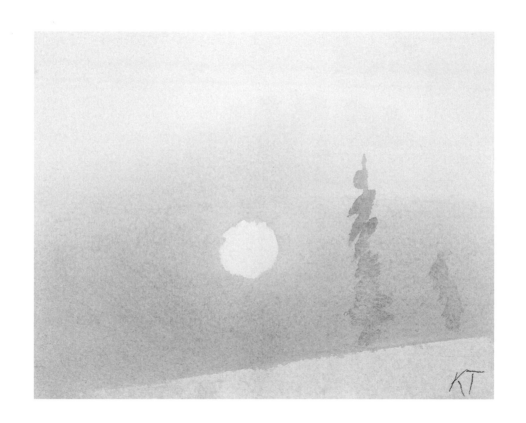

27. Kåre Tveter DESEMBERSOL I FROSTRØYK / DECEMBER SUN IN FROSTY MIST, 1985, 13 x 17 cm

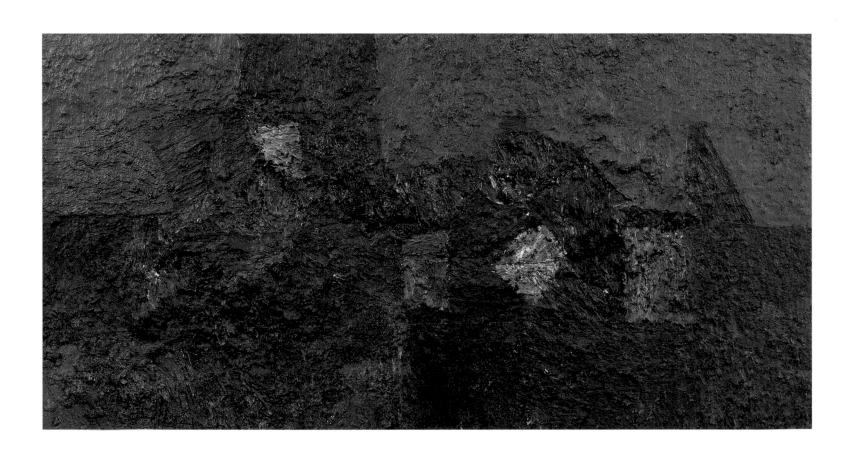

28. Jakob Weidemann STEN OG MOSE / STONE AND MOSS, 1961, 64,5 x 122 cm

One thinks in the same way as the landscape one inhabits. That's what gives us our characteristics and our character. The strength of a painting lies in its colour, and colour without light is nothing. With colour and light one can achieve both strength and intensity, side by side.

JAKOB WEIDEMANN

If I were to mention one person who has had immense importance for my understanding of art or the development of my taste, it would be Jakob Weidemann. I first bought one of his paintings in 1961. Over forty years have passed, and I never grow tired of it. I have always had a soft spot for paintings that have several layers to them. These are paintings I can live with for a long time, perhaps because they have several physical and aesthetic layers, so they are ambiguous and offer more to contemplate. In this, Weidemann is a master. In his paintings we come face to face with the forces of nature. The tiny details and colours in his compositions are symbols, or markers that lead us to our own interpretations. We can almost smell the autumn leaves, which is wonderful, yet it reminds us that summer is over and the cold season is approaching. The lightest, or palest paintings in the exhibition have a happy exuberance about them – they are almost ethereal and seem to represent cosmic flowers and eternity.

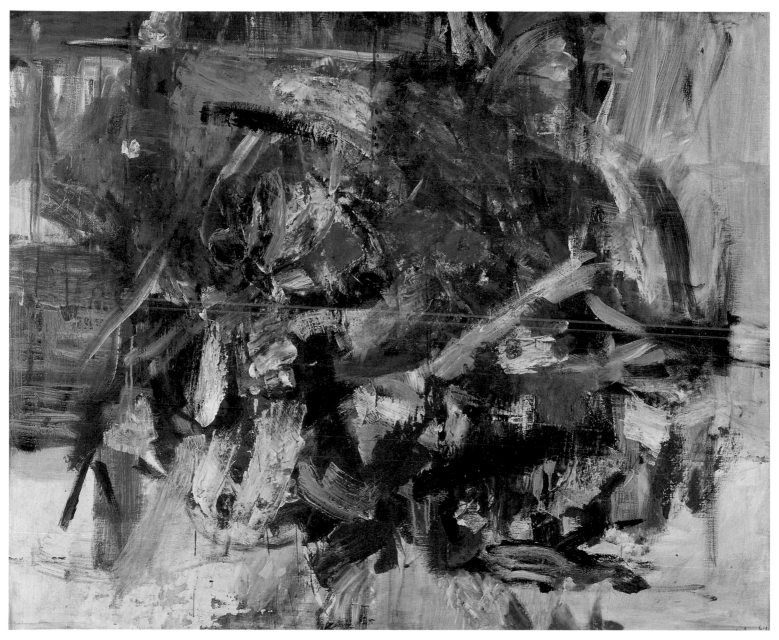

29. Jakob Weidemann HØSTLØVET FALLER / THE AUTUMN LEAVES ARE FALLING, 1964, 91 x 110 cm

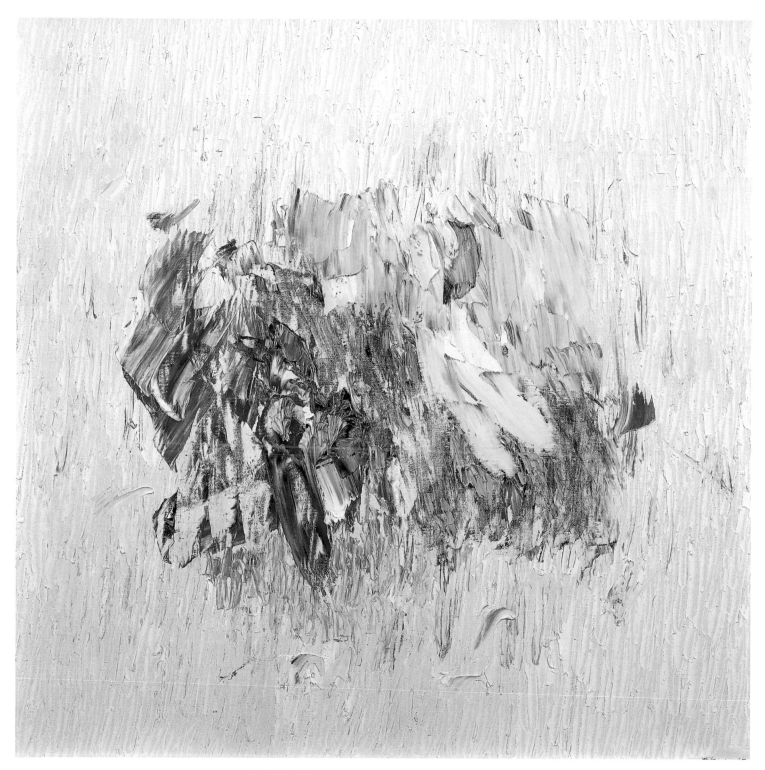

30. Jakob Weidemann SOMMER / SUMMER, 1987, 100 x 100 cm

For many years, Queen Sonja has taken pleasure in both art and Norwegian nature. They represent different forms of recreation and mental re-charging for the Queen, who has a hectic daily schedule. She first visited the area around Storfjorden in western Norway over 20 years ago, and has continued to return to this dramatic landscape. In order to become properly acquainted with this terrain, one needs to exert substantial physical effort, but these magnificent landscapes have given the Queen tenfold in return.

During the last few years, Queen Sonja has taken her camera with her on these trips, and in 2002, the book *Resonance* was published. The book features a selection of the Queen's photographs, together with watercolours of the same landscape painted by Ørnulf Opdahl.

The dialogue that emerged between these two was very fruitful, and they both wished to share this with others. A broad selection of the Queen's photographs and Ørnulf Opdahl's watercolours are exhibited here for the first time.

RESONANCE

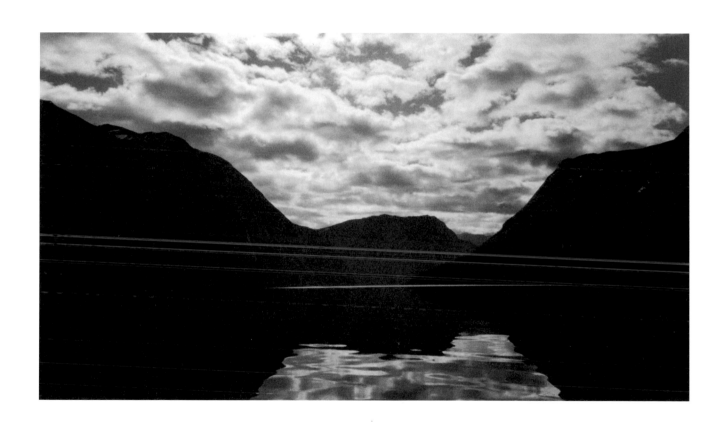

35. H.M. Queen Sonja GEIRANGERFJORD

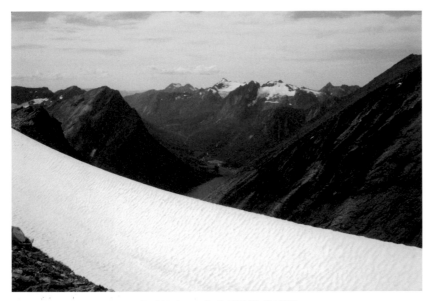

47. H.M. Queen Sonja TOP OF GLACIER

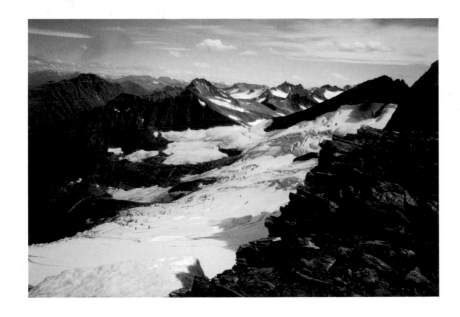

49. H.M. Queen Sonja THE REINDAL GLACIER

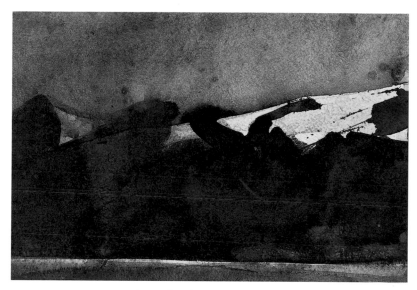

68. Ørnulf Opdahl FJORD LANDSCAPE

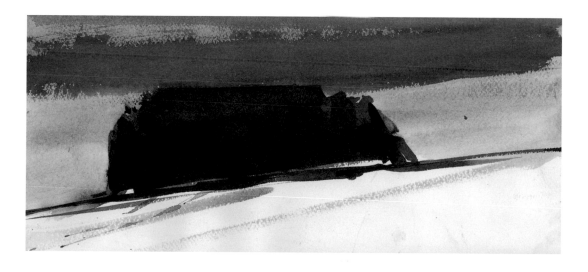

72. Ørnulf Opdahl THE MOUNTAIN RÅNA

67

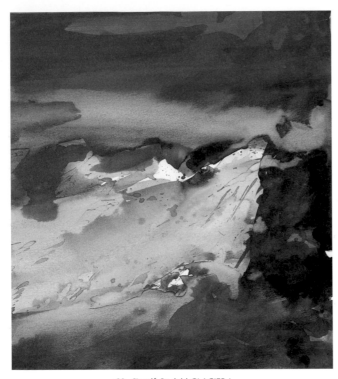

60. Ørnulf Opdahl GLACIER I

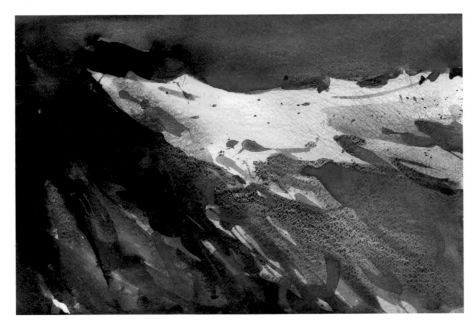

66. Ørnulf Opdahl GLACIER II

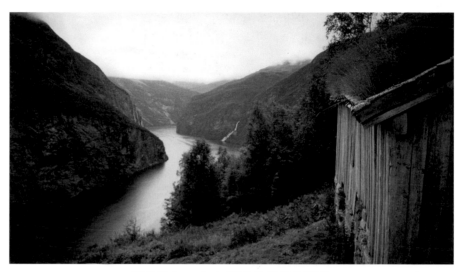

36. H.M. Queen Sonja EVENING AT BLOMBERG

40. H.M. Queen Sonja EVENING AT VARTDAL

69

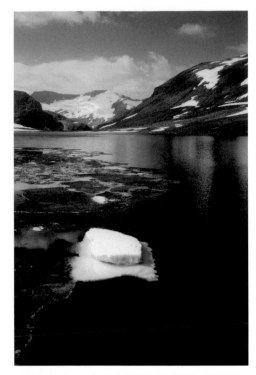

50. H.M. Queen Sonja MOUNTAIN LAKE IN SUMMER

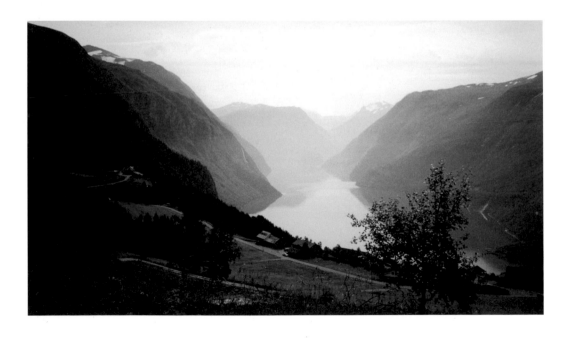

33. H.M. Queen Sonja TOWARDS TAFJORD

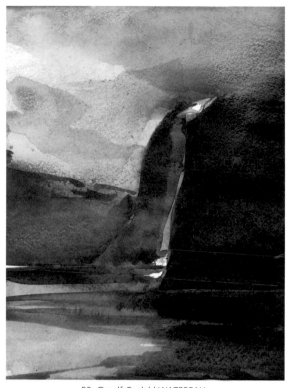

59. Ørnulf Opdahl WATERFALL

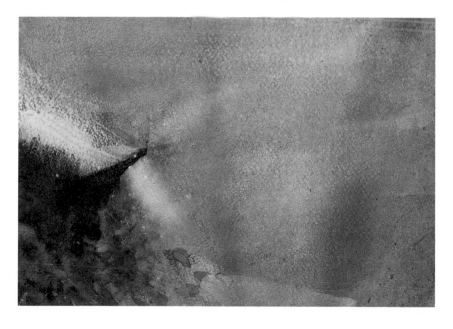

62. Ørnulf Opdahl IMPRESSIONS OF LIGHT

LIST OF WORKS IN THE EXHIBITION

Bergman, Anna-Eva
1909 – 1987.
In 1952 she moved to France Married to painter
Hans Hartung

1) *Vingeskygge / Shadow of a Wing*, 1955
 Oil and silver on canvas, 46 x 72 cm
2) *Sølvfjell / Silver Mountain*, 1986
 Oil and silver on canvas, 12 x 21,5 cm
3) *Sølvhav / Silver Sea*, 1986
 Oil and silver on canvas, 14,5 x 22 cm

Borchgrevink, Hanne
Born 1951 in Oslo.
Lives and works in Grue Finnskog. Married to painter Tore
Hansen

4) *Solskinn / Sunshine*, 2000
 Acryl on canvas, 160 x 180 cm
5) *Vinter / Winter*, 1994
 Woodcut, 17 x 24 cm

Ertsland, Alf
Born 1946 at Stord
Lives and works in Oslo

6) *Landskap med tre / Landscape with Tree,* 1987
 Oil on canvas, 100 x 85 cm

Hansen, Tore
Born 1949 in Grue Finnskog, where he lives and works.
Married to painter Hanne Borchgrevink

7) *Sovende elg / Sleeping Moose*, 2003
 Acryl on canvas, 72 x 98 cm

Heske, Marianne
Born 1946 in Ålesund.
Lives and works in Oslo

8) *Uten tittel / Without title*, 1986
 Videopainting, mixed media on canvas, 66 x 94 cm
9) *Natt ved Fanaråken / Night by Fanaraaken,* 1987
 Videopainting, mixed media on canvas, 96 x 129 cm
10) *Tafjord,* 2001
 Videopainting on plexiglass, 65,5 x 47 cm

Jenssen, Olav Christopher
Born 1954 in Sortland, Lofoten.
Lives and works in Berlin

11) *Insulan,* 1997
 Acryl and oil on canvas, 220 x 200 cm

Opdahl, Ørnulf
Born 1944 in Ålesund.
Lives and works on the island of Godø, close to Ålesund

12) *Fjordbygd / Village by the Fjord,* 1991
Oil on canvas,145 x 145 cm
13) *Kveld – Ålesund / Evening – Ålesund* 1997
Oil on canvas, 50 x 50 cm
14) *Gråvær / Overcast Weather,* 1998
Oil on canvas, 121,5 x 121,5 cm

Pihl, Thomas
Born 1964 in Bergen.
Lives and works in New York

15) *Prearticulation no. 12,* 2004
Oil on canvas, 123 x 152,5 cm

Rickhard, Leonard
Born 1945 in Tvedestrand.
Lives and works in Arendal

16) *I dialog med stillheten – nymåne /*
In Dialogue with Silence – New Moon, 2001
Oil on canvas, 152 x 178 cm

Rumohr, Knut
1916 – 2001. Born in Leikanger, Sogn where he lived and
worked most of his life

17) *Detalj i sne og is / Detail in Snow and Ice,* 1968
Oil on canvas, 80 x 100 cm
18) *Glødende sommerlandskap / Glowing Landscape*
of Summer, 1988
Oil on canvas, 100 x 80 cm
19) *Vårløsning / Spring Thaw,* 1987
Oil on canvas, 22 x 28 cm
20) *Fjordarm / Arm of the Fjord,* 1988
Oil on canvas, 22 x 28 cm

Tufta, Bjørn Sigurd
Born 1956 at Askøy
Lives and works in Bergen

21) *Janua Coeli IV,* 1993-1998
Oil on canvas, 60 x 120 cm
22) *Ekko – kyst / Echo – Coast,* 1985
Various techniques on canvas, 120 x 185 cm

Tveter, Kåre
Born 1922 in Sør-Odal.
Lives and works in Nittedal by Oslo

23) *Vinterstemning på Skaugum / Winter at
 Skaugum,* 1984
 Watercolour 36 x 53 cm
24) *Morgenlys Svalbard II / Svalbard in Morning
 Light II,* 1987
 Oil on canvas, 99 x 110 cm
25) *Morgen / Morning,* 1988-89
 Oil on canvas, 65 x 80 cm
26) *Isfjorden / The Ice Fjord,* 1984
 Watercolour, 13 x 17 cm
27) *Desembersol i frostrøyk / December Sun
 in Frosty Mist,* 1985
 Watercolour, 13 x 17 cm

Weidemann, Jakob
1923 -2001. Born in Steinkjer
Lived and worked in Oslo and at Ringsveen by
Lillehammer

28) *Sten og mose / Stone and Moss,* 1961
 Various techniques on plate, 64,5 x 122 cm
29) *Høstløvet faller / Autumn Leaves Are Falling,*
 1964
 Oil on canvas, 91 x 110 cm
30) *Sommer / Summer,* 1987
 Oil on canvas, 100 x 100 cm

Warhol, Andy
1930-1987

31) *Celebrities: Crown Princess Sonja,* 1982
 Screenprint and polymer on canvas, 102 x 102 cm

WORKS FROM *RESONANCE* IN THE EXHIBITION

Photos taken by Her Majesty Queen Sonja

32) *Regndalstindene*
 Frame 49 x 63 cm
33) *Towards Tafjord*
 Frame 49 x 63 cm
34) *Foxgloves*
 Frame 63 x 49 cm
35) *Geirangerfjord*
 Frame 49 x 63 cm
36) *Evening at Blomberg*
 Frame 49 x 63 cm
37) *Tussevann*
 Frame 63 x 49 cm
38) *Morning Light at Blomberg*
 Frame 38 x 63 cm
39) *Wellhouse at Skageflå*
 Frame 49 x 63 cm

NORGE: Contemporary Landscapes from the Collection of Her Majesty Queen Sonja of Norway

Exhibition on view at Scandinavia House: The Nordic Center in America, New York.
March 3 – May 25, 2005.
Organized by The American-Scandinavian Foundation in collaboration with The Royal Court of Norway.

The selection of the works has been undertaken and supervised by Her Majesty Queen Sonja
with the assistance of consulting curator Karin Hellandsjø

Acknowledgment

The American-Scandinavian Foundation enthusiastically thanks Statoil North America Inc., Principal Corporate
Sponsor for all Norwegian Centennial Events at Scandinavia House, which provided important support for this project.
The Foundation also thanks the Royal Norwegian Consulate General in New York for their support of educational
outreach related to NORGE: Contemporary Landscapes from the Collection of Her Majesty Queen Sonja of Norway
as well as SAS, Scandinavian Airlines, for assistance in transport of the exhibition.

The American-Scandinavian Foundation

The American-Scandinavian Foundation (the ASF) is a publicly supported, nonprofit organization that promotes international
understanding through educational and cultural exchange between the United States and Denmark, Finland, Iceland,
Norway and Sweden. The ASF carries on an extensive program of fellowships, grants, trainee placement, publishing,
membership offerings, and cultural activities. In October 2000, the ASF inaugurated Scandinavia House:
The Nordic Center in America, its new headquarters, where it presents a broad range of public programs furthering its
mission. The ASF has associate members and subscribers worldwide. More than 27,000 Scandinavians
and Americans have participated in its exchange programs since 1910.

Edward P. Gallagher, President
Lynn Carter, Executive Vice President
Erik Sigge, Cultural Programs Specialist
Joan Jastrebski, Director of Communications
Victoria McGann, Manager of Scandinavia House

CATALOGUE

Editor: Karin Hellandsjø

Translation: Jennifer Lloyd (from Norwegian)

Photographer: Kjartan P. Hauglid, The Royal Court page 23, 24, 27, 30, 33, 39, 40.
Halvard Haugerud page 3, 16, 18, 19, 21, 28, 31, 34, 36, 37, 43, 44, 45,
47, 48, 51, 53, 54, 55, 56, 57, 58, 61, 63.

Design: Øivind Pedersen – Labyrinth Press, Oslo

Published by The American-Scandinavian Foundation, New York. 2005

Printed in Norway by:
RenessanseMedia AS, Oslo
PDC Tangen AS, Oslo

ISBN 0-9719493-3-6

Notes to the artists statements on pages 17 to 52:
[1] Svein Olav Hoff: Hanne Borchgrevink. Oslo 2000
[2] Bergens Tidende 20.11.1991, Fanaposten nov.1998
[3] Smaalenes Avis 08.08.2003
[4] From an interview in I.L.Lystad: På sporet av det norske. Oslo 1996
[5] Harstad Tidende 21.06.04
[6] Holger Koefoed: Ørnulf Opdahl. Oslo 1994
[7] Exhibition Catalogue, Royal Caribbean Art Grant 2003
[8] Svein Olav Hoff: Leonard Richard. Oslo 1996
[9] Østlandsposten 07.11.1995, Moss Dagblad 04.02.1999
[10] Stavanger Aftenblad 25.10.2003
[11] Arvid Møller: Kåre Tveter. Vinterlys. Oslo 1993